• GRANITE UNDER WATER

Granite Under Water

Poems

JEANNE LOHMANN

FITHIAN PRESS • SANTA BARBARA • 1996

These poems appeared in the following periodicals:

America: "Catching the Light"; *Blue Unicorn:* "Wild Oats, Point Reyes";
Buffalo Spree: "The Blue Pen," "Ceremonies," "Invitation"; *California
Quarterly:* "August Orchard at Chico," "Frequently a Letter"; Friends of
the *San Francisco Public Library:* "Stow Lake"; *The Lyric:* "Elegy," "High
Seas"; *Mushroom, the Journal:* "Walking on the Earth"; *Napa Review:* "The
House of the Pearl Merchant"; *Passages North:* "Toward Morning the
Inuit Grandmother Talks to Herself," "Water Lily"; *Plains Poetry Journal:*
"Pathology Report"; *Poetry Northwest:* "As a Little Child," "Festival: Bon-
Odori," "Griefwork," "Regardless"; *Poetry San Francisco:* "A Place to Live";
Rain City Review: "Crows in Winter," "Motel on the Interstate"; *Seattle
Review:* "Kiev: The Monastery of the Caves"; *Shenandoah:* "Saint
Patrick's"; *Vivo:* "Granite Under Water"; *Western Journal of Medicine:* "The
Fairytale Turns Backward"; *Yankee:* "Gulls," "Heartwood"; *Zone 3:* "Going
Back."

Copyright © 1996 by Jeanne Lohmann
All rights reserved
Printed in the United States of America

Published by Fithian Press
A division of Daniel and Daniel, Publishers, Inc.
Post Office Box 1525
Santa Barbara, CA 93102

LIBRARY OF CONGRESS CATALOGING-IN-PUBLICATION DATA
Lohmann, Jeanne.
 Granite under water : poems / Jeanne Lohmann.
 p. cm.
 ISBN 1-56474-180-X (pbk : alk. paper)
 I. Title.
PS3562.O463G7 1996 96-11783
 811' .54–dc20 CIP

For Hank.

And if the earthly no longer knows your name
whisper to the silent earth: I'm flowing.
To the flashing water say: I am.

RAINER MARIA RILKE, *Sonnets to Orpheus,* II, 29
(translation by Stephen Mitchell, Vintage 1989)

Contents

• GRANITE UNDER WATER

• *One*

Granite Under Water

The sun plays light from bits of mica. Water
runs its own sweet language over rocks
I have known a long time. And iris growing,
slim-budded, sweet scented, fragile. Delicate
as orchids curving into arcs of yellow, white,
the different shades of purple. Slender tongues
that say how simple we are, how beautiful.
Such petals bruise easily. I watch you

walking with children on the wet steps
of the fountain. Unsteady from rock to rock
you guard your footing. You could be
climbing out of time, Jacob surrounded
by all his laughing angels. The wild iris
flowers in us, we move forward and backward,
reminded by walls that are always opening.

No one could see bottom where great slabs
of rock plunge into green water. They
are huge outcroppings of stone, islands
where blueberries grow, O too thick
and too many, our fingers and mouths
turned blue with trying and with kisses.

In glacier country mountain goats
so high we almost couldn't see,
you singing your hiking songs
in transparent air, alpine flowers
clustered underfoot, stars springing
from rocks, the spiky grasses.

These places we live we return to,
the flowers, the durable river. I am crying
for air I cannot breathe. It is luminous,
this country where your death is granite
under water, a single yellow iris
standing clear from edges of stone.

Pathology Report

The names of cancers make such music
on the tongue, harmonious sounds.
Astrocytoma. Falling, like a star.

If comfort's anywhere I used to think I'd find it
patterned in the sky, ordered in legends of light,
exploding nebulae, that lawful mystery
we probe and point our instruments to learn.

We careful watchers of heavens, hoping
for history, know night is what we have
to celebrate, and in the dark I dream
of starfish. They hump
on tentacles that move, and standing, eat.

Almost precise, our tools scan shadows
where the ocean's trapped. Indifferent chaos
is apparent in the cells, the sludge
where random creatures hide,
elusive strays that wait to come and feed.

In the Wood

We can't go back by bread or shining stones,
The birds have eaten all the crumbs. No mercy
from the moon that gives the creatures unfamiliar
shape and eyes. What heat there is we hold
between us, in our hands. Loudest at night
we hear each other breathe. When we wake
we are here, by the roots of a stricken tree.

The snow-white bird may fly to us singing
the sweetest house in the world, we won't listen
though the berries are bitter in our mouths,
the tart wild taste morning after morning,
fruit that grows while we sleep. Love is a way
we feed each other, hulls and the black juice
stain the ground, dark as the eye of the tree.

On the Marrow-Bones

Please love, one still summer more
drunk on honey and lazy roses.

Before the black petals drop into the box
and while our bodies want to sing, sit near me

under the moon, say beauty though your blood
robs you of music, let us worship

sweet life, its gifts of meat and honey,
the two seas our shadows swim in.

Afternoons

In the mystery of affliction,
in the body's beauty that through time
earns its own patina, let us cherish
each other, honor the rough changes
in our skins, the fingers' broken nails,
the knee and the knuckle-aches, even our
voices croaking their old kinship
with the frogs.

When the point is no longer our need
to be doing something, in the light
of these late afternoons that bless
the familiar bed, let us say what is
with us in the room, speak
for those who entered and left
our lives, and for those who stay.

In our diminished bodies that we keep
on loan, and while we are here
holding what is left,
say how great a mystery
everything was, and is,

now we begin to learn
to be quiet and grave and happy
before the coming of incidental
and indifferent death.

Song

Touch yellow leaf
before it goes,
and tawny hair.
O walk barefoot
in moving sand,

our running grain
of gold.

Turn tongue around
the shining fruit
and bright in stone
find flecks of fire
to warm us when

the air and ground
are cold.

Daisies

An inexpensive bouquet, I thought
I wanted something honest and
immaculate. But how organized
and sequential these white ordinary
petals centered around yellow, pungent
with scent I do not like,
flowers that begin

immediately to change. Too long
in the same water, nothing is
ranker. The stems rot,
serrated leaves turn slippery.
I can't re-do the wedding,
daisies didn't tell the years I
marry you daily, our green

and private ceremony. You fill
my hands, my arms, together we
find fresh flowers, fragrances,
an entire spectrum of colors, wild
cuttings from forest and meadow,
the quiet generosity
of our cultivated garden.

Once, on the Road to Olema

Late summer, the grass gold
on Elephant Mountain. Bicycling
between sun and shadow, we pump and glide
on the morning road, keep the animal
in sight, repeat its name to invoke
the very weight and bulk of this day.
All the elephants we know
inhabit other continents, stories,
the zoo. But here and now
above us is the god.

Stopping at noon, we
rest on rock, drink bottled water,
eat apples, sandwiches. The dry weeds
scratch our legs, leave marks.
We want to make love in the open,
have the mountain see us:
the immense body of this particular day,
its shape of tawny grasses
against an unclouded sky,
symmetry we will not see again together.

Wild Oats, Point Reyes

All morning walked away
and resting here
secure above the sea
we are sky and grain,
whole in burnished air,
so sure of good for this
unblemished time,
our view of heaven
crossed and framed
by swaying stalks of gold,
the bent grasses.

October, My Love

after Ingeborg Bachmann

In October my love is with the scarlet and yellow leaves
that fly in the wind. I gather him in my hands.

In October my love comes to me like the deer at night
hungry for the summer-leafed crowns of the new trees.

In October my love tastes of apples and woodsmoke. He
has hickory nuts in his pocket. When he walks in goldenrod

he does not loosen the pollen. The grasses do not tremble.
In October my love is among the roots. He invites me down.

In October my love lives with the shaggy purple dahlias,
the symmetrical white and bronze. He rides off in a royal coach

and the Frost King holds the reins. In October my love
cries in the language of the wild geese. Preparing to go

he feeds with them in the fields. In October my love
is a lighted candle behind a mask. Waiting at the door

of his dying, he welcomes the children who ask for sweets.
In October my love shines like Venus in the southwestern sky.

His touch is losing warmth like the sun,
his words are the first rains of winter.

The Fairytale Turns Backward

I'm afraid of this lake we walk around
where even mallards on the sunny log
bring one more question, and the long dives
of gulls call to you where you stand
on the stone bridge. Some spiteful fairy's
charming you toward darker water.
Enchanted by minnows and turtles,
by creatures of puddle and pond,
you're being pulled into green algae.

No matter how many kisses I give you
you go away from me, changing into cold,
your thin blood shifting channels at night
under layers of wool and flannel. The chemicals
do what they can, but they are not magic. There is
no more magic we know of anywhere.

We live very close to the deep well. Already
you have forgotten what we were like together
and you ask me why I am crying.

We have finished eating from a single plate,
you will never sleep in my bed. I cannot
take you with me to the palace.

Late

The room is ready, the bed turned down, arrangements
made for privacy he says he much prefers. We're asked
to see no one interrupts his necessary business. Perhaps
we plan too much, fail to trust him to his own devices.

We're certain he is coming. Rumors reached us early
in doctors' talk of probabilities and percentages.
Anticipation doesn't mean much, he may demand hospitality
we can't afford. He's the one to choose, invites himself

on his own quite definite terms. Punctual elsewhere, he's
been with neighbors down the block, stayed the night with
 friends,
checked in across the street. With us he keeps postponing.
They tell about those visits, say how much he leaves behind:

housekeeping chores, clean-up, the gifts no one expects.
They mention fingermarks on silverware, dirty linen
from the bed, say he was impossible to talk to,
went everywhere in the house, never left a forwarding address.

The children kneel on the living room sofa, their faces
close to the window. Father is late and mother's upset,
her supper drying in the oven. Eat now or later, the food
will go down hard to swallow, forcing the throat to open.

Journey by Water

There's a place on the ocean dark green we've been coming to
a long time, where I turn my heart around and go back
across unfamiliar water. We have put out forever

from land we lived on, we are permitted few provisions.
Enough for the transfer where you step into
the other boat rocking toward us on tides that rise

of their own fullness. The outline blurs from here
and disappears under one more wave. We never look
into the sun, what's near is singular, all that is sure,

our ordinary arms pulling the oars, how I am taking over
rowing while you doze in the bottom of the boat, your head
heavy with unknown things. Salt water holds us up.

Drifting by night our rhythms change. I cannot name
what swims beneath us, say if landfall's there we go
so far to find. Against immensity you claim the mercies

of God, you sing against the wind. We are given nothing more.
And I cannot tell what weather will be on us when we sit
opposite and fixed, moving apart through widening water.

Regardless

Dress this way or some other it does not
matter. Pull on a warm sweater or
the blue shirt, who will notice? Death
comes regardless of what we are wearing.

Choose today because it is here, because
it is gray like iron and heavy with fog,
this will not be the one that finds you
gone into light, having slept farther
than any dream you imagine or tell me.

Fixed absolutely on cold and the weather,
attentive to signals—a shift
in your breathing, the cough, the mole
by your left elbow, changes in any one
of the systems you hoped would save you,
you muddle a long time through. You do not
give up or acknowledge that this could be it,
the last and final turn toward a great difference,
toward afterward you once said would be wonderful.

We go on in what we are wearing and we read
of the breakthroughs, the cancers withering
in mice, clues that could mean something
to someone. We go on measuring the air,
hold our fingers to the wind, we register
the boring details of illness, the body's
dull limitations. The signs appear
only to cancel each other, and nothing
we wear is appropriate to the climate.

Between what we ask or think we are
capable of choosing, the weight of that door
hangs between us. In sunlight or fog it is there
and iron, and it will swing open. Will warmer weather
come on us then and surprise us back into childhood,
the day a stranger arrived bringing presents
we took without thought for his house or
the distant country he came from?

O when will you dream in through and go on
past the bullies who wait on nightmare corner,
to the other side of the brilliant colored capsules,
the knives and injections, the humming machinery
of research, past anyone's efforts to help?

It is time, I tell you, to risk it. Go over,
my love, and check out the country. Maybe
it's there, groundspace for the grand recognition,
home where the clown and the saint are
fully restored in the family. Maybe there
the temperature's milder and opinions
soften somewhat in the air of the place.

When you go, I will never be ready.
Not now, for these words.

Or then, for the music
I will go down on my knees and beg for.

Minding Our Tongues

one-sided conversation with a famous poet

I've just read your new, right-on beautiful poem
and it set me thinking of the time I stood beside you
in a buffet line at a poetry conference. My poem
reminded you of your father, you said, said it was good work
and I should clean it up and send it off. Kind, humorous,
helpful with revision, committed to excellence,
and grumbling over your lunch tray about some failure or other,
you dropped the casual words offhand, to no one in particular:
 "You'd think I had a brain tumor or something!"

My husband's exact illness. You couldn't know
or how long, my necessary escape to free days for poetry.
But I know your work, your prizes and awards, remember
you told us: "When you write, pay attention with your life.
If you let words go cheap and easy, the work suffers,
we suffer, truth falls through the cracks. You can't
fool around; we're too mysteriously connected to fool around."
In life as in poems, you said we have to mind our tongues,
know who we're talking to.

I wish I'd told you, seized you by the shoulders, shouted
anger at you, shouted, "Shut up! You don't know anything
 about this,
you don't know what you're saying. He's dying of the changes
in his head, and *that's* no joke!"

If I had told you we would have been embarrassed
and we might have learned something. There, in line
beside the fruit and salads, the bread and cheeses, we
could have turned wordless and weeping,
put our arms around each other.

The Ice Opens and Closes

As the skater at night
out far on softening ice
turns toward shore near thin edges
of black water. His blades
cut narrowing arcs, he comes close
again and again, refusing to go under,
refusing dark he is bound to,
testing the unfreezing mirror.
He cannot miss his broken reflection,
the stars pull him deeper,
sky and water meet in his blood,
the pressures equivalent and final.
Cold begins at the ends of his fingers,
his feet, and high on the cheekbone ridges,
his body stiffens, the air
burns back in his throat, he
cannot close his mouth,
the skater at night
too late for winter,
too early in the spring.

Toward Morning the Inuit
Grandmother Talks to Herself

Today I go with the Bear who comes in my dreams.
I have softened too many skins with my teeth
and the animals want me. My fingers are the bones
of my needles. Snow cries in the spring,
nobody likes to leave, my father told me.
We are here, we go other places, we make room
for the children. My son's wife is moving
under her blanket, my body takes no heat
from the ashes. I have been cold before.
The Bear outside, I hear him, it is time.
There is not much he will have. It is time.

Based on an interview by Robert Coles

Small Birds with Mysterious Individual Instructions

This is how I live, how I try to,
with death already here
exuberant behind the mask, flawless dancer
every day on the streets
where as we pass, we recognize
how alone we are.

As a flock of starlings soars together, then
hangs in the air, each bird more and less
significant than the whole until
the flock reverses itself and wheels
out of sight.

Coasting down the boundaries of confusion
to a place past words, the real test
is dispersal and surrender. Death

crouches and spins, hovers
whimsical and capricious,
perfect in final resolution,

and we are rarely elegant, hardly ever
willing to take on the new shape,
our appointed place in a configuration
that merges and dissolves,

small birds with our mysterious
individual instructions. But pulled toward each other
and toward the formation,
dark kite in a windy sky.

Self Portrait: Metamorphosis

your arms and hair
turn into light
your torso to fire

before death only gold
is pure enough
to bear
exaltation

your fingers drop small irregular suns
your Medusa head erupts in bright snakes
your face gone in a glow

of brushstrokes charged in leaps of yellow
that reach to embrace us as if you could
hold in your arms life that is burning
and falling away.

As a Little Child

 If there's nothing
on the edge of this black hole he told his students
was out there in space, still, dying's not the way
he expected. He's forgotten answers he wants
so much to know. Instead he thinks about pencils,
they didn't belong to him but he took them.
He remembers candy he stole from the corner store,
the time he hurt the dog. He wants absolution,
he wants Mother to say I love you, it's all right,
you'll know better next time.

 Too late, he can't
give anything back. Whoever's in charge has
thrown out the ledger, he's lost his notes
for the test, his learning comes down
to a single question: will they let me in?

 He's ready, he wants
to play Red Rover, he's waiting for a signal
that it's right to come. Who calls his name,
who'll have him on their side? Maybe he doesn't
weigh enough, he can't feel his feet touch
the ground he knows he's loose and running over.

The black hole is opening its eye, outside
there's too much gold, the grass, the flowers.
He can't reach the tube he wants out. Where's
the voice coming from he can't understand
and why won't his own voice say what it is
he really wants?

Catching the Light

> ...the crucifixes...were all finished and chased
> with great care, their sharply tooled surfaces
> designed to catch the light of the nearby candles
> — from *The Vatican Collections*

Blasphemous or no, all week the theme recurs.
Apologetic, awed, our son tells me your body
looks like Christ's, his sculptured form in marble,
old master paintings. He says you could be
some long-boned martyred saint with narrow torso,
prominent ribcage, your head fallen to the left,
beard brushing your chest. Even a draped sheet.
This much is given, that we stay, and stay
silent. Agony we aren't permitted to enter.

The night before the hemorrhage, the last night
you speak in sentences, you mention candles,
big ships you think you see on water. The window
frames buildings, a parking lot. Opening your eyes
wide as if to let in light from the darkening room
you shape a kiss there's no way to give.
Outside the flawless images of art, our hands
affirm the holy life of mortal touch that's here
without illusion. Warm, familiar, sure.

• *Two*

Heartwood

In this picture taken on one of the good days, when I
backed away from you holding the camera, you
seemed to shorten and disappear. It may be
you have gone into the life of the trees.

As if feeling for something you knew they had,
energies to mix with your blood, an exchange
of systems and forces, you put your hands
on the redwoods and said, "My arm feels good."

When we tried out loud the words, "You might not make it,"
we stood under ancient giants on that path
of filtered light above the rose garden. You promised
this would be a place you'd come to if you could.

When it was no more possible for you to walk with me
I found fresh cuts on the trees. Sawed-off places,
yellow wood exposed, thick ridges folded around
old scars, the fine grain split, darkening and coarse.

Setting Out the Pansies

Expecting his death, and needing to save everything
I asked what flowers he remembered
and he said he bought pansies in flats
for Mother's Day, drove the family car
out Lyndale Avenue to Bachman's, came back
with the cut-down boxes on the seat,
the pansy faces nodding with stops and starts.
During the war he sent them by wire from the Pacific,
said he didn't forget the borders she always
planted close to the house, her special vases
for pansies with their short stems.

•

After the first surgery
in a hurry to get out of bed
he knocked a vase off the hospital tray,
spilled water and flowers,
couldn't reach the broken pieces
on the floor.

This morning, that memory. Words of a hymn:
O love that will not let me go.
In a stranger's yard
so many pansies
I want to and can't touch
the yellow, white and purple
variegated velvet faces.

In our yard, the bulbs are finished,
the dry stalks lopsided
where I cut them, and the thin brown leaves,
make room in the dirt, set pansies
to face the sun.

Stow Lake

Here's where you stopped, too tired
for going farther. We kissed a light goodbye
and waved each other on. I walked away
then turned to see you standing there, and still.
I felt your eyes, how far they followed
where your body couldn't take you
to the bridge, the island, the hill of terraced vines
that gives again the feel of warm Italian summer
ripe and full. Here's where you paused,
and when you turned to pace your careful slow descent
down steps of shadowed stone, I let you go,
this one of many times we practiced separation.

A Place to Live

Even though—both of us knowing you could die any time,
both of us *wanting* to believe when you said this would be
the place you'd come to if you could—I seldom
come here and wait on this log turned almost into stone.
Even though keeping our word was life between us, given
all *that* in trust, still I seldom walk under these trees,
redwood and eucalyptus, the branches of Monterey pine
over the path opening farther than we could see the morning
you told me you'd surely try to come. I've tried being here,
stopped and stood quiet to see if you could make it, but I'm
always either too early or too late and just miss you, in time
only for a voice that tells me living my life's a way of being
faithful. Even though the trees keep changing and love is
behind or ahead of me in the clearing I trust as I trust
this ground: the duff and dark needles underfoot, the light
through high green lace pulling the trees into the sky.

Griefwork

When they disappear into their skulls and
go out of their eyes like burrowing animals
who hide in tunnels under the leaves, when
small heaps of dirt indicate something lively
and quick escaped us, and went that way,

how slowly love reassembles. If they return
we would have them undiminished. Almost we see them,
almost they seem to be with us, and nearly whole.
But light moves from the trees and we go down where
they are, under stone and the wood, under the leaves.

Crows in Winter

The sun in fog
shows white on white,
cover of frost
on frozen ground,

and four big crows
in brooding light
yaw through air:
discordant sound.

In concert dark
with the crying birds,
and omens they are
for good or ill,

my grief takes shape
in winter words
brittle as ice,
and strident. Shrill.

High Seas

This is the sea that is made of tears.

This is the sea that is made of tears
left over from times we didn't cry.

This is the salt that grinds in the waves
of the restless sea that is made of tears
left over from times we didn't cry.

This is the tide that pulls us in
stung by salt that grinds in the waves
of the angry sea that is made of tears
left over from times we didn't cry.

This is the flotsam all askew
in a heavy tide that pulls us in
stung by salt that grinds in the waves
of the sea that troubles our years
left over from times we didn't cry.

This is the swimmer setting out
riding the flotsam all askew
in the sorrowful tide that pulls us in
stung by salt that grinds in the waves
of the shining sea that is made of tears
left over from times we didn't cry.

After Earthquake the Widow Repairs Her House

Filling the cracks with plaster, she
paints them so they almost don't show,
finds others breaking through
as the house settles.

In window-frames out of plumb
she sees his absence, the presence
of that Other Woman she lost him to.

When she finds them
wherever they are
will they be so changed
she can admit desertion
as one more fault
in the country of his death

where nothing fits in her life,
the foundation shaken loose
while she cried "O, no!" to the falling bricks,
the power went off, and there was no water?

Aftershocks keep coming,
rock her bed,
open new separations in the walls.

Walking on the Earth

Come from the earth and lie down
in sunlight, the smell of pine needles
where the lost body is given back.
Alone, I will not lie down.

The ground that holds your body does not
remember the prints we made. Hooves of the deer
erase us, and the small, claw-footed birds. Trails
the beetles make cover our signs. Our weight
we thought so heavy was not enough. Hours after,
the ferns rose up, the aster and coneflower.
On the dunes the iceplant did not die, and the seeds
of green jasmine and hayfeather scatter in the fields
to grow in another place.

Walking on the earth, I sing our songs
but I will not lie down to her promise of warmth,
the sweet odors of return. I would bruise my hands
with asking, find fossils in my skin, traces
of stone and insect, outlines of the bearded grasses.
Between my teeth the tough stringy weeds
and grit, the taste of salt.

Traveling Alone

No matter what airline I take
some stranger sits next to me
until you take the stranger's place.
Nobody notices your shoulder against mine,
our knees and hands touching,
the familiar closeness of the long married.

My dear, I don't know how you manage it,
passing security to come aboard,
but you do. Through sunglare off the wing
we watch the changing clouds,
below us houses and forests,
rivers, the mountains.

I don't say anything,
try not to breathe you away,
try to hold onto your smile that is astonishing
as this shell that holds my life,
these rivets and layers of metal
all there is between me and everything
waiting to rise up from the ground.

You stay until the landing gear's in place
and the wheels touch down on the runway.
As I exhale my involuntary thanks
you go without goodbye.
I'm back in my other life.

One blinding midnight over Greenland
I couldn't begin to think of sleep,
stood at the tail window of a British jet,
staring down at the snow dazzle on peaks, chasms,
that landscape of blue ice,
the glaciers
structured like cells.

For a while together
spellbound in praise
we were so quiet nobody noticed.
The man with the camera went on taking pictures
I knew he wouldn't catch on film.

When I turned from the window
I lost us again, and my life
plunged out of the plane,
this time somewhere over Greenland,
the icefields frozen in light.

Kiev: The Monastery of the Caves

In this underground corridor, the walls
are close enough to touch. In coffins behind glass
the bodies of holy men, famous metropolitans
of the Eastern Church, lie in the dim light.
Black cloths embroidered with gold and silver
cover their faces; the dark hands
show at the ends of their sleeves.

The painted eyes in icons of these dead
watch past their bodies preserved by dry air,
the even temperature. Behind windows
heaps of skulls and bones are mixed in group graves
that go a long way under the hill.

On this tour we speak seldom and softly, keep moving
the fifteen minutes it takes to walk through,
come up inside the church. To blazing candles,
music. Rachmaninoff.

 In this amazement I think of you,
your flesh and skeleton taken apart
in the useful pursuits of Western medicine,
remember the bench with your name
in the park we walked in, our words:
Celebrate and serve life. And I hear in the music
the sound of water flooding a dry creekbed,
the voices of children,
their tumbling games in the grass.

Love Poem

In the Uzbek night, in Tashkent
I do not have to dream or conjure you.
You come, bodily almost, into my room.
Almost you're here, around me, beside
and above me, your flesh as firm and cool,
your hair alive, my place on your shoulder.
The magic maintains. You've found me, love,
though I have come far to this hotel
in Central Asia, and you live elsewhere
in a country no one is allowed to visit.
But here, in the Uzbek night, in Tashkent
where the balcony railing makes a geometric design
of shadows on the white wall, in the blue light
that is clear before morning and evening
you come as if love keeps its place
among the minarets, and I am the *muezzin*
calling the faithful to prayer.

Ceremonies

Be ready to mourn if you go to a wedding.
If you go to a funeral, be ready for dancing.

So many invitations, and they're burning
my fingers, the paper curling away
like char in the wind. Candles
melt in my hands, the warm wax
cooling into a perfect glove
that fits my skin.

At this marriage the bridegroom
wears your shoes, steps out
on grass and rose petals.

I think of the herbs we put into your pocket
the morning of your death,
the candle beside your body
at daybreak.

Be ready to mourn if you go to a wedding.
If you go to a funeral, be ready for dancing.

The spirited music of violins
tells me you can't stay away,
tells me you've come here
for the waltz and the polka.

All around me the dead
accumulate faster than the living
and the light of their darkness is everywhere.

In the Russian folk museum at Zagorsk
a finely carved wood mold holds the shape
of goodbye, the farewell cake. When
it is brought out, everyone is given a piece.
Everyone knows it is time to go.

Be ready to mourn if you go to a wedding.
If you go to a funeral, be ready for dancing.

The House of the Pearl Merchant

For in my nature I quested for beauty;
but God, God hath sent me to sea
for pearls.

— CHRISTOPHER SMART

Behind me on the hills
greenhouses filled with mandarin *satsuma* oranges.
The path curves up a long way to a wooden gate
opening into his garden ordered by stone and sand.
Lines from bamboo rakes designed the pattern of this ground.

Light enters through *shoji* screens.
Graded by size into dishes and trays, the pearls are luminous.
It is darkening late afternoon and they make their own shining
in the room. When he shows them they rain through his fingers.
A few slide off and roll away. He says I may keep what I find
and I sleep all night in his house.

Morning warms the *tatami,* and I
wake slowly, remember yesterday on his boat.
In his sea trap he caught a small red octopus.
He turned it inside out so it wouldn't climb away.
He insisted his grandson touch it. The boy is three,
he cried a long time.

Below the pines and red maples
it is a great distance to the bay, to islands
raised by old volcanoes. Water is very clear
where oysters feed in their beds,
harvesting the seed that grows against their flesh.
Because he thinks it will make me brave,
the merchant hopes I will go with him
another time in his boat on the water.

But I can't see deep enough
to pearls forming. I haven't learned
why I cry easily, why I am afraid.
The gift I hold is small and hard in my hand,
and I go from his house as I came here
by way of his garden taking the long path down
over rocks to the shore of the sea.

Festival: *Bon-Odori*

While I am in this world I light fires for the returning
spirits of the dead who circle back and join us. Awkward
as I am, I enter the dance in August, *Bon-Odori,* the drums
insisting the dead are finding their way. If I stumble
in the reversals that accompany going forward and keep on
dancing, I meet the missing, find them in the old rhythms
of fishermen, miners and farmers, their departing waves
around me, the hidden treasure in rocks and fields. When
I follow the dancers ahead of me sure of the pattern, follow
their legs and hands as others come on behind me, our long line
opening and closing, the beat of the *taiko* connects us
strong as the pulse in my body that steadies and holds it.
I light lanterns in the *yagura* and bonfires on the hills.
While I am in this world I get up and dance for the dead.

• *Three*

Saint Patrick's

She can't say what pulled her in, off the street to this place
near the back of the church, under a green stain of windows
named for the Irish counties, her seat between Galway and Down.
Repeating the names, she takes a book from the rack. Words
on the bound pages in the missal tell her it's *ordinary time*.

Other ordinary people cross themselves and kneel, go near
some saint they hope will intervene. She'd welcome intervention,
but how do the faithful know which saint to call when so many
are looking, their arms open? Even the janitor with his bucket and
 broom
seems to know where to go. He bows to the Virgin, touches her foot

no adoration wears away. He strokes the fixed fall of her robe, his
prayers go from his lips into smoke that wavers around this body of
 Mary.
The woman's prayers won't cross her heart. If she could go to the
 altar
she'd light a candle for her husband. It's five years since they
left a white one burning in a chapel in Florence, unfamiliar ritual

he wasn't embarrassed by, fire he placed in the beseeching rows
before a blue and gold saint with a carved message under the feet:
"Come, Holy Spirit." If something *was* given, some extraordinary
blessing that steadied his soul in the changes, dying the way
he did, she'd like to know. She can't know, she knows it's only

a foolish question. She has to go farther, back to that spring night in Chicago, talking the moon down late in Jackson Park, their love so young she wanted to know everything. "What's the purpose of life for you, what's the purpose?" He said, "To grow in Spirit," words that sealed their covenant. Thirty-seven years and she has to

go to heaven without him. Already the saints are losing their bodies, they're floating through the green windows in pieces of light. Her
 eyes
try to catch them, her knees are sliding to the floor. She's almost
 ready
for prayer. Her hands are coming together, they open and close into fists at the ends of her arms that have nowhere to go.

Motel on the Interstate

Indoors or out, there's no sign of you
in this bright assault of May remembering.
I watch my thought take shape, go toward you
any way it can, disguised as you are,
having taken your body with you God knows where.
I see the sky and hills so far above the freeway
too dangerous to cross, walk circles
in the asphalt parking lot, praise green
in the shrubs, a scarlet rhododendron
coming on, pink dogwood, old growth cedar
saved from new construction.

Like coils of unused cable, like lumber
the years pile up between us from that morning
to this. And my four o'clock waking
in the ugly room. No particular reason, no
memory repeating a friend's light touch on my shoulder
to tell me you were going. Still, strangely
startled out of sleep, I checked the clock:
the luminous red numbers identical,
to the hour. Restless in that wide bed
I punched the pillow down. To make
some shape that I could hold.

Spring Rain

This Spring like no other, the dead
 are everywhere, petals underfoot

after the hard rains. Pink and white,
the trees are repeating themselves in the water.

Green takes over as the blossoms begin
to let go. And the apricot tree last year

more beautiful than this, fixed past
our going or wishing. Their going

changes everything, dying turns the dead
into saints, the ordinary hallowed by

absence. All the petals blow down,
so many they fall like miraculous rain,

the dead dropping light as kisses, and we
blow kisses after them. This Spring, like no other.

Frequently a Letter

comes I want to show you, and I can't. Try
every trick the mind invents, it doesn't work.
Death's made a gash in the sky, like the river
in that Chinese legend I heard the first time
without you. You're where I can't come
to show you letters that say how much
you're missed, ask you if what people tell me
is true, how you think about your life,
even how it was with us when we were the sky,
the Milky Way falling through us, the stars
playing on our bodies too happy in the river
to realize silver everywhere, the shining
that carried us. Not even once a year
will anyone let you cross back. All the answers
are questions I ask to hold you, but I can't
get through the words, words keep us
where we are, in the dark I see
we will stay, on this side and the other.

Morning Glory

Think of blue and try to locate this
on a palette: near lavender, but bluer,
Ipomoea heavenly blue, a single morning glory
so large it fills the window of a dream
I'm waking to find

recollected *Amen* and *Hallelujah,*
reassurance everything is
and will be, all right,
nothing to do
but breathe this summer in,
this morning's fragrance of cut grass,
the dew shining in spider webs.

They say the morning glory's a symbol
for marital bliss, one of a hundred flowers
on the Chinese Qing dynasty vase. I count
twelve on the side I'm looking at, each
with five petals and curled edges, white veins
fading against blue, trails that come out of
and disappear into, nectar, the sweet center.

No one can tell what's lost,
pure blue that won't be,
the flower opening in the night,
the silent bell.

Elegy

My love and I go walking
in the morning early,
up the roads and down the roads,
by running water, surely.

I take him where a cedar wind
blows fragrant on the air;
I give him feathers, little stones,
forget-me-nots to wear.

I tell him recent news of kin,
anecdotes I've heard.
Although I chatter on and on
he never says a word.

And if I cannot see the ground
for rain that's in my eyes,
the wet smell of good earth
still takes me by surprise.

My love, he takes me walking
in the morning early,
up the roads and down the roads.
By running water, surely.

Gulls

Two, at home in the unmarked sky,
take the air their wings are made for
and I load them with messages, say
they're us, and we're flying,
say you are ahead of me
on a wheeling circuit of wind.
You will never come down or fall
and my raucous cry will follow
wing and tail, lagging behind you.
I take food from other birds
and when I come inland to water
I am greedy for both of us.

Water Lily

One at a time so as not to rock the canoe, we
leaned to smell them, their wild cups offering
fragrance like blessing. You cut a lily,
hung it over my ear, took that snapshot I keep
with pictures of my life supposed to be over.
I still look toward you as if I can't believe this
is happening, as if I wanted to be a water lily only
for you and couldn't, knew it would take years of sun,
the lake levels rising, to make a climate right for
lilies with yellow hearts and snaky stems, flowers
out of Eve's tears in swaying that's almost swimming.

The summer before your cancer killed you, we knew
it was going to kill you, and went home to lake country.
Fishing off the deck of the pontoon boat, I caught
the first fish, a bullhead with stingers. You can't
kill that fish, even with a hook in its mouth it multiplies,
stirs up the lake bottom. With his foot on the bullhead
your cousin forced its ugly mouth open, pried the hook loose,
knifed the fish in the belly, threw it back, sure it would
go on living. Nothing was biting. There weren't many keepers.
At dusk we turned off the motor, slid home quiet.

Close to shore a water lily moved on its stem
and I cut the flower, gave it to you. All night we
breathed it in, that beauty. Even now, holding what's left,
the flat petals thin as paper folded over the empty space
of the flower's heart, I find veins that look like gold,
a dry fragrance.

Invitation

If you look for me you will find me in my ordinary life
that shines each day with your absence, as I do, repeating

what I did when we were alive together, in time. If you come
you will see I do not live in the vortex of my grief, but here

in this pleasant house where I am naked and at home,
going about the usual tasks, tending what must be done.

Coming back you would be comfortable, not embarrassed
by familiar routine. It would almost be the same. Easy.

Describing a Circle

The dead who seem to ask much
ask little, only that we
call them by name, remember
they lived without halos.
Even you, my darling,
ascend in a circle of light,
swim in a new element, long strokes
that take you away from me, as finally
in a hard pull I took the gold band
off my finger. We want to be happy
and I tell you it is not easy.
My thumb worries the deep indented line,
reminds me we are no less married
by years the body wears,
the daily rite of absence
sacramental
in the skin.

August Orchard at Chico

The almonds are still green. Along
the branches and the quiet leaves
the flat fur cases begin to split,
kernels pulling loose from porous shells,
the fibers stringing off. The halves
turn pink and come apart,
open like mouths, their dry edges
shriveling in the warm air.

I want to tell you I come here often,
walk carefully on the overturned dirt,
brush the black ants off my legs.
The symmetrical rows of trees
angle off in shadow, and I don't go far
into these fields, keep to the limits
of their life as, without you,
I keep the boundaries of my own.

Year after year the trees come to life
and blossom. Whether or not the owner
of this orchard saw us then or sees me now,
the sun is hot on the old trunks we
are reaching around, and we touch
the orange lichen, the tough bark.
Then as now we come away like thieves,
almonds in our pockets.

Angels on Maple Park

Because this world is beautiful and varied
and because sometimes
it is terrible, how much
the angels of forgetting and remembering
make possible, enable.

In the long afternoon of my late October
life, the astonishing leaf color on the parkway
brings me to a full stop,
sends the entire texture of the day
spiraling in a tangle of transcendence,

each melancholy autumn poem that I
almost remember, each leaf that once
so caught me I had to take and keep it,
revelation fallen from the trees,
those torches in the high blue sky
that year after year I looked up and into
with undiminished amazement,
all that green-veined scarlet
and yellow and brown on fire again
under the sun of this year's season,
the burning glass of its light
directed to *this* street, *these* maples.

And the angels who teach us to forget and to remember
remind me that what was terrible and beautiful
is long since accomplished, and is here
enhancing the glory of the leaves.

The Blue Pen

Thinking it belongs to her, taking it off the counter
ready to sign the bill, she notices different words:
 The USS *Solace,* World War 2, (Iroquois-Solace-Ankara)
 1927-1981 by Ens. H.C. "Pat" Daly, MSC, USN-Ret.
The blue pen looks like hers, like one of two dozen her husband
sent for before he died. Inexpensive ballpoints, gifts for friends,
pens with both their names in gold letters and "Joyous Yule.
 Peace."

This spring, now, a perfectly ordinary day, she wasn't expecting
reminders. Never the *Solace* sailing out of old letters she's
been reading, V-Mail and airmail in her fragile scrapbooks with
yellow newspaper clippings and pictures of the hospital ship,
a photo of corpsmen and officers standing by the deckrail,
Hank in the back row, forty years younger, clean-shaven,
crewcut, wearing skivvy and navy whites. Espinoza, Berndt,
Chief Laedthke. And Daly, the strong black signature that hasn't
faded. He liked popcorn, lived in California, was a pretty swell
boss, the warrant officer who ordered his men, "Keep 'em level!"
when they lifted the stretchers aboard. Daly, the one who said,
"Well, men, we haven't done much today, but we'll give 'em hell
 tomorrow!"

And the clerk says she knows him. A nice man. Comes in maybe
twice a year. No, nobody knows how to reach him.

"My husband was on that ship. He died two years ago. And please,
I have to have that pen."

As if there will be other news,
astonishments in her life
here on this side of the world
with only one way to write it down.

On the Whole

Looking back, there's no way to tell our fable
better than it was, redeem nightfall in the green space

we lived in. Married past the lines of breath, we
exist now in an older unity, part of the immense

sadness of lovers, companions in their joy, our
place reserved in a handful of words, enough

to hold through the silence on either side. It's not
irrelevant then, that I imagine I see you

walking ahead of me, or that stopped here
in a temporary spot of sun, I yield one moment

to thanks, for such time as we had. Before death,
in the limits of what was possible, we did what we could.

Going Back

You will not be stone that warms to my body's blood,
that river beneath my skin you move on now you
have no other way to travel. Here, in the bend

of this road we stopped to love each other. Here, stone
turns emblem, sign from the small river the rain
made last night near the upper fields where all afternoon

I have been mourning your death. In late sun I practice
my new song in the stubble, seeds on the ground. You will not
be in the many waters of this country I come back to,

depths I used to be afraid of, dark changes going deeper,
the sheer granite plunging off, ooze at the lake bottom.
Once, throwing smooth flat stones, you told me your brother's

always hit the water at a cleaner angle, skipped farther.
Under a new bridge all our waters come together.
Lifting my arms in your old morning gesture to the sun

I know I can keep nothing: no fish out of this river,
no bright cardinal's flash to the opposite bank. Never
the particular gold stone that found me on my way

to the fields. I have to give them back. What I want
is more than the singular shape of a stone, its geology,
or low above the water a quick scarlet bid.

The Bridge

Looking into the distance of landscape, paintings, photographs, always
I am drawn to that point I can almost make out where everything meets

like the railroad tracks I walked as a child. Or the place where
the trees lean into and touch each other. Sun on a California river

is not today's sun, but past light on other water. The double arch
of this bridge opens two ways, these stones reshape a different pattern,

older strata crossing the Cam at Cambridge. It is not fall but summer,
your first try at poling a punt, a laughing failure. This morning

a boat that is not here moves downstream on a bright river that is
here and in England. Light refracts in circles we made and make

and travel through. Lifting and lowering the long pole, you
send the punt on its wavering course, and, love, we are in it

still floating in light, trailing fingers in the shallows,
resting between the green banks, coming slowly to shore.

For New Lovers in North Country

You will not be always alone here. You will find others
and greet them, lovers out of time and long ago honeymoons
on these border lakes: Gunflint, Seagull, Saganaga, Basswood,
Namakan. Say the names and they turn to music the dead will hear
and sing back to you. Be attentive when you pass on the portages.
Follow their trails, as the voyageurs followed the trail of moose
and caribou. Lift your paddles to hail them as you come round
islands of stone and alder and blueberry, or make your way
across the muskeg. Look for canoes on the gleaming water,
the straight-backed men and women bending and stroking
or resting and riding with the current. You will find them,
the lovers here before you, find their names on old portage signs
nailed to the trees. If you don't see the names, be easy.
The lovers are here. The beaver have seen them, the great pike
in the black waters know they are here. The heron that watches you
watches them running the rapids not far ahead. Their voices
echo around you in the cries of the loon.

If white and yellow waterlilies still bloom in these lakes,
cut one and fix it in your hair. Breathe that fragrance
with your kisses. On stormy nights lie together in your tent,
listen to rain on your overturned canoe. Listen to your hearts
that are safe as the packs stowed under the gunwales, your matches
dry for new fire, the map folded in its case. If the trails
are poorly marked, no matter, you will find a way through
tamarack and birch, come tired and breathless to the next
blue lake. They are good company, the lovers who sat in the sun
on these same high rocks and tossed crumbs at persistent jays.
Take pictures of yourselves naked and solitary in this wilderness,
come home with the taste of blueberry that never leaves your
 mouths.

Beachcomber

On San Gregorio Beach the sea turns over its thousand tons
of salt, new sand washed to shore at every turning,

generations of skeletons, trails of ghost crabs in curves
the waves leave, the incessant grinding of shells

the ocean breaks into remnants of recognition: you and I
were here, and you are not. With every turning your words

tell more than you intended, changed by the ways I hear
and hold them. I save everything. Driftwood. Shells.

Your words the light lives in and slides away from, words
so rounded now and smooth you might not know you said them.

Stepping barefoot over kelp on the hot sand, I try to
give attention to the spilling over, but just (I insist)

for the time it takes tears to gather and fall, to concentrate
salt on my skin like the finest trace of remembered touch,

the moisture evaporating in the heated air, the clouds
moving in new shapes, out to sea.